The Meal

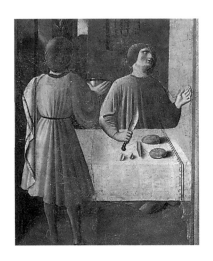

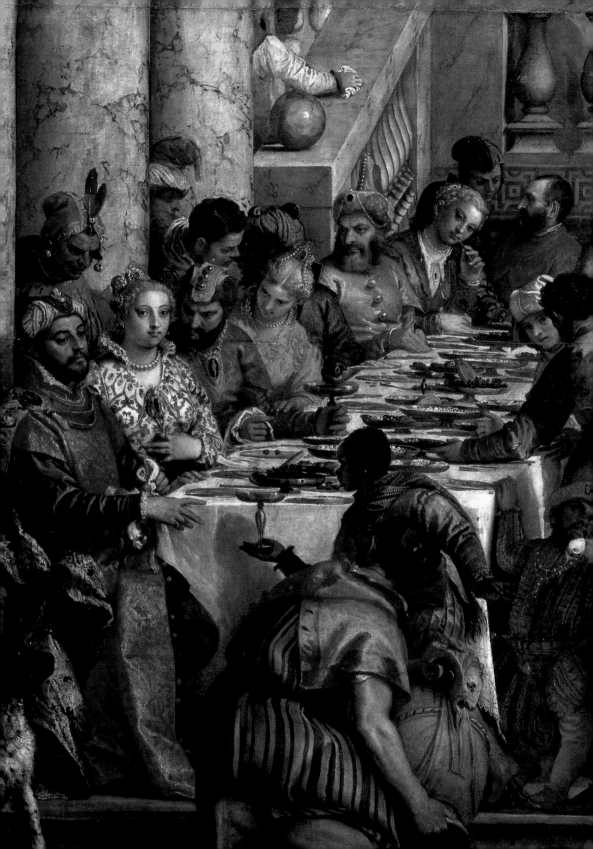

THEMES IN ART

The Meal

ALLEN J GRIECO

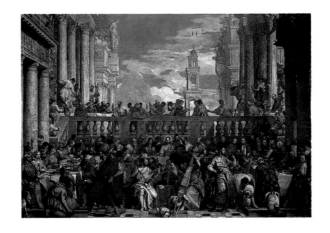

SCALA BOOKS

Text © Allen J Grieco 1991
© Scala Publications Ltd and Réunion
des Musées Nationaux 1992

First published 1992
by Scala Publications Limited
3 Greek Street
London W1V 6NX

in association with
Réunion des Musées Nationaux
49 Rue Etienne Marcel
Paris 75039

Distributed in the USA and Canada by
Rizzoli International Publications, Inc
300 Park Avenue South
New York
NY 10010

ISBN 1 85759 002 3

Designed by Roger Davies
Edited by Paul Holberton
Produced by Scala Publications Ltd
Filmset by August Filmsetting,
St Helens, England
Printed and bound in Italy by
Graphicom, Vicenza

Photo credits: Artothek 16; Bridgeman
4, 12, 17, 21, 31, 36; © RMN; 1, 2,
18, 19, 23, 24, 32, 33; Scala (Italy) 5, 6,
7, 9, 10, 11, 12, 14, 27, 29

FRONTISPIECE Detail of 9,
Master of the Orange Cloister
*St Benedict receives the poisoned
bread*

TITLE PAGE **1 Paolo Veronese**
***The Marriage at Cana*, before 1568**
Oil on canvas, 669 × 990 cm
Paris, Louvre

2 Jan Davidz de Heem
***Still Life*, c1650**
Oil on canvas, 69 × 58 cm
Paris, Louvre

Contents

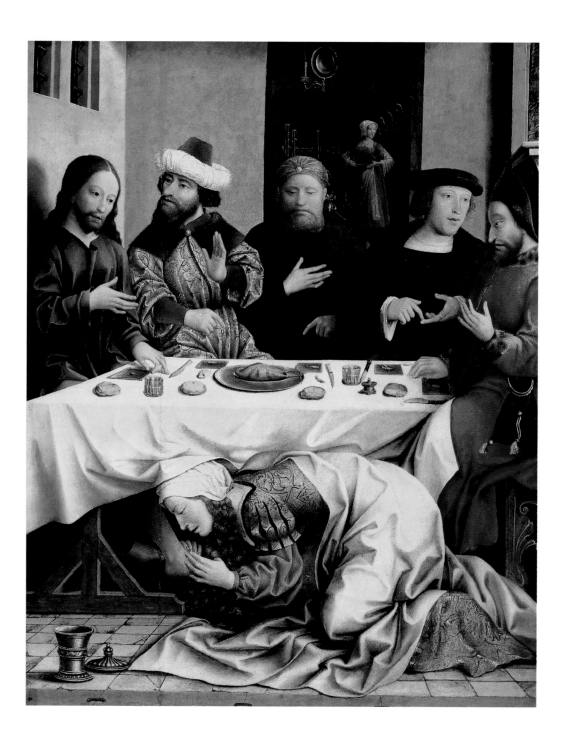

Introduction

F ood is a cultural product like any other. As such has been neglected until recently, perhaps because it was felt to be beneath the dignity of serious enquiry, or perhaps just because most people eat every day of their lives. But if eating is the most basic of cultural acts, it has profound consequences. Our very environment is created— or destroyed—by the need for food. Not just today but in history; the barren fields in Giotto's paintings are a vivid testimony of the impact that demographic pressure and dietary habits had on the European environment in the decades preceding the Black Death of the mid-fourteenth century.

Attitudes toward food and the table have undergone a long and profound change in Western history since the Middle Ages. In six centuries we have gone from a time when food supplies were always short and when famine struck frequently to our present health problems due to excessive food consumption. This radical change in the availability of food has also determined a basic change in the way we see it. From a quasi-sacred object of desire it has slowly become a mass commodity.

Paintings constitute a particularly sensitive documentation of this changing attitude to food. It must not be forgotten, however, that images do not necessarily reflect reality in a simple and straightforward way, and the representation even of such an apparently uncomplicated subject as food usually needs to be de-coded if the viewer is not to be misled. Nevertheless works of art, almost despite themselves, document the changing habits, customs and fashions of an age. They allow us to follow the slow but steady changes in how people ate, where they ate, what they ate and with whom they ate.

Paintings also document, with a wealth of detail, the importance of meals and banquets in bringing people to a table, thus reinforcing

3 Master of the Mary Magdalen Legend
Christ in the house of Simon the Pharisee, 1515–20
Oil on panel, 87.5 × 70 cm
Budapest, Museum of Fine Art
Special dining room tables did not exist during the Middle Ages and the Renaissance. Trestle tables, such as the one revealed here beneath the tablecloth, could be set up more or less wherever the diners chose to eat. Only in the eighteenth century, with the creation of a special room for dining, did the dining-room table become a permanent piece of furniture. The square pewter plates on the table are telltale signs of the Northern European provenance of this painting.

the links responsible for the cohesion of traditional societies. From the rigid and rather bare tables of medieval banquets to the overabundant tables of the seventeenth and eighteenth centuries, the reason for holding such gatherings was not just eating together, it was above all a social and political event in which the menu, the seating arrangements and the very shape of the table itself constituted an outward and visible sign of the hierarchies at work.

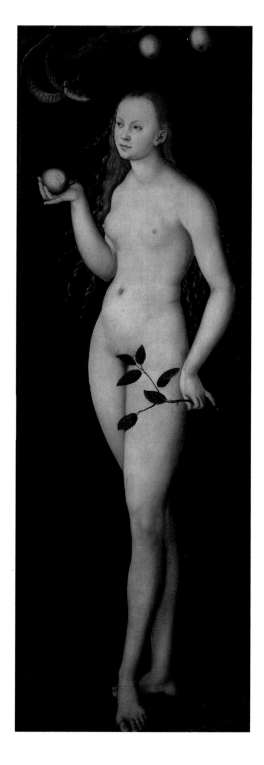

From the Middle Ages to the Renaissance

"The serpent...said unto the woman, 'Yea, hath God said, Ye shall not eat of every tree in the garden?' And woman said unto the serpent, 'We may eat of the fruit of the trees in the garden: But the fruit of the tree which is in the midst of the garden, God hath said, "Ye shall not eat of it, neither shall ye touch it, lest ye die"'.... And when woman saw that the tree was good for food, and that it was pleasant to the eyes, and a tree to be desired to make one wise, she took of the fruit thereof, and did eat, and gave also unto her husband with her: and he did eat."' The biblical account (Genesis, 3) of the Fall of Man was much commented on by medieval theologians, whose interpretations were hardly limited to pointing out that Adam and Eve had committed the sins of pride and disobedience. The first man and woman were also responsible for succumbing to gluttony which, as most of them pointed out, led to the even graver sin of lust. After eating from the forbidden tree "the eyes of them both were opened, and they knew that they were naked." It was this second interpretation that most inspired the many artists who decided to paint the original sin of man. The apple and its rounded shape—since it was this fruit that was chosen to carry the responsibility for man's expulsion from Eden—was often a thinly disguised symbol for Eve's breast, and so continually reminded the viewer how closely gluttony was related to lust.

Adam and Eve's encounter with the forbidden fruit neatly sums up the ambivalent attitude western culture has had (and still has) towards food. On the one hand, the desire for new and even exotic foodstuffs has led, over the centuries, to the adoption of a great

4 Lucas Cranach the Elder
Eve, 1528
Oil on panel, 167 × 61 cm
Florence, Uffizi

Although the original sin was one of pride and disobedience, theologians and artists saw Eve as a temptress who provoked man's downfall when she offered him food that led to carnal knowledge. The apple held in Eve's hand is closely associated with her breast and is a reminder that the sin of gluttony, one of the seven deadly sins, leads to the even more serious one of lust.

9

variety of new foods and ingenious ways of preparing them. Spices, for example, were the prime reason for which long and often dangerous trade- routes were kept open, for European markets of the Middle Ages and the Renaissance seemed to require them in large quantities. On the other hand, the Church maintained and encouraged a cautious and even suspicious attitude to food that, in some cases, led to very parsimonious consumption or even abstention from anything that was considered more than necessary for survival. The rules laid down for all religious orders, for example, prescribed how much food was to be served and when; these regulations were supposed to ensure that the meals served to the brethren were adequate for survival but not conducive to any (sinful) pleasure. However, as a fourteenth-century Italian author reminded his readers, even a plate of very unassuming food could constitute a major temptation: was this not one of the conclusions to be drawn from the biblical story of Esau, who gave up his birthright for a plate of lentils?

Given the association between food and sin, it is hardly surprising that medieval tales often cast the devil in the role of cook. Wily Satan was well aware that pleasure in eating was one of the best ways to cause the downfall of an otherwise virtuous and resistant soul. This association between cooks and the devil lingered long in western culture, to the extent that, as late as 1628, John Earle could write in his *Micro-cosmographie*: "The kitchen is his hell, and he the devil in it, where his meat and he fry together." Ironically enough, in representations of Hell before 1400, artists often imagined that the damned ended up being devoured, but only after being tortured by the most familiar instruments, suddenly seen in a new and horrifying light. These instruments, in fact, often originated from no other place than the kitchen. Roasting spits, skewers and

5　Anonymous artist
Hell, early 13th century
Mosaic in Florence, Baptistry
Representations of Hell before 1400 often concentrated on an imagery of devouring in which the damned were roasted and boiled as if they were nothing more than food for the devil.

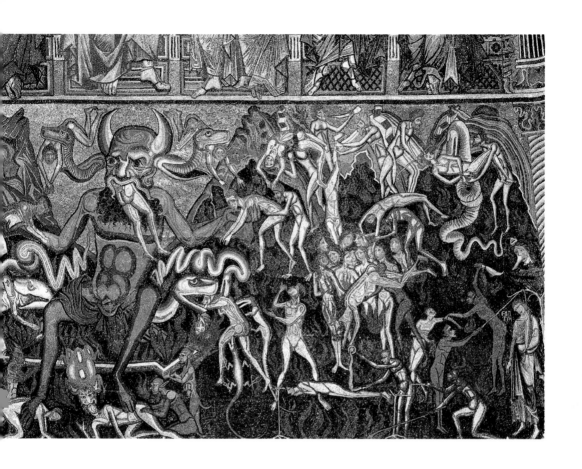

11

the large medieval pot used for boiling the poor man's vegetable soups were turned against their habitual users. The gluttonous damned thus ended up being roasted and stewed like the food they had consumed when they were alive, doomed to become the food of fanciful monsters.

The representations of food and meals which one encounters most often in medieval art are generally restricted to special events or special diets (such as Last Suppers, meals described in the Bible, the meagre dinners served in monasteries). One must be careful not to consider these religious representations to be realistic examples of how people ate, for both the sacred and the lay meals depicted in medieval art were heavily laden with symbolism. The rare exceptions to the general rule of a religious context for the depiction of meals are the banquets of kings and of the powerful. However, despite the heavy codification of medieval menus as they appear in paintings and miniatures, the accessory details can tell us a great deal about prevailing attitudes and customs precisely because they were considered unimportant and mundane. A good example is the tablecloth which always appears in paintings portraying meals. Tablecloths, mentioned in the inventories of even the poorest families, were the only object without which a meal could hardly be considered human. Tablecloths delimited the area where one ate even if there was no table. An amusing miniature contained in a manuscript of the story of Tristan shows Tristan in his bath being served a meal on a board resting on the sides of the tub. Even such a makeshift table has a clean tablecloth on it.

The tables portrayed in medieval paintings and miniatures appear starkly bare and simple to the modern viewer. Part of this impression is due to the refusal of artists to give any importance to food. However, a table like the

6 Ambrogio Lorenzetti
Madonna del Latte (Suckling Madonna), c1340
Tempera on panel, 90 × 45 cm
Siena, Palazzo Arcivescovile
The nursing Virgin became an important iconographical theme, especially in the early fifteenth century, and might have consituted a conscious attempt to persuade the upper classes to practice maternal breastfeeding rather than give their children out to wet nurses. The use of cow's milk, widely adopted only in the nineteenth century, was considered dangerous since it was believed that it would transfer animal qualities to the child.

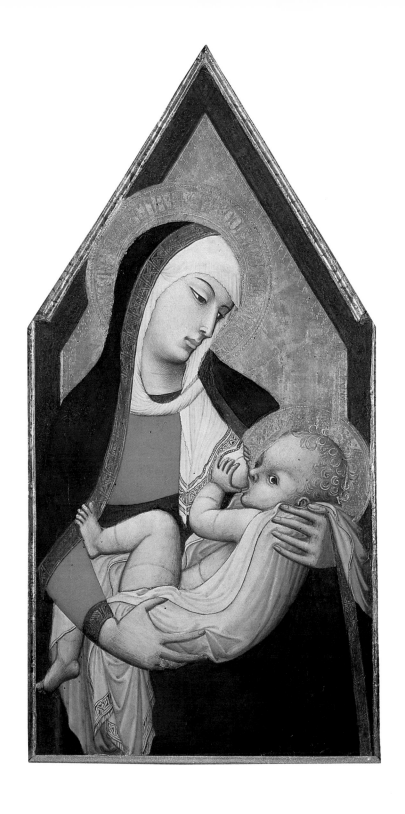

13

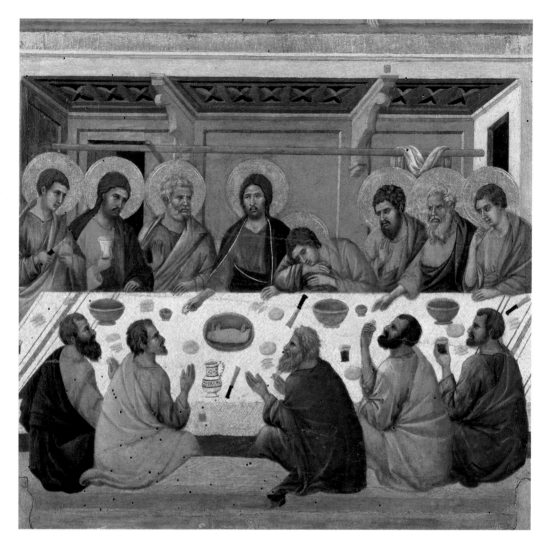

7 Duccio di Boninsegna
The Last Supper, panel from the Maestà
altarpiece, 1311

Tempera and gold on panel, 47.6 × 50 cm
Siena, Museo dell'Opera Metropolitana

The lack of objects on medieval dining tables was partially due to
the fact that knives, bowls, cups, and trenchers were shared by
several diners at a time. This Last Supper features glasses for red
wine even though in the early fourteenth century glasses were
still a rarity. In the background, a towel hangs from a wooden
pole. It was probably used to dry the hands of the diners after the
ritual hand washing ceremony which began and concluded all meals.

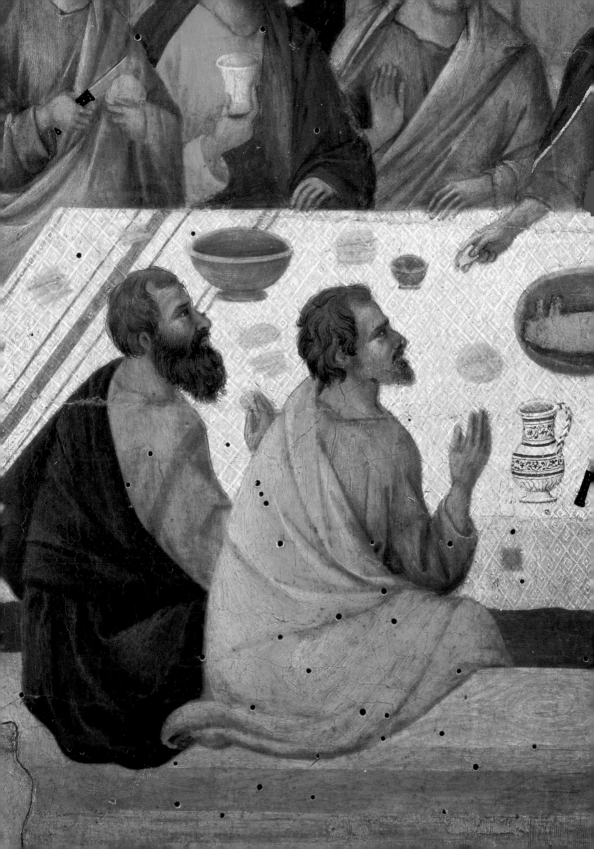

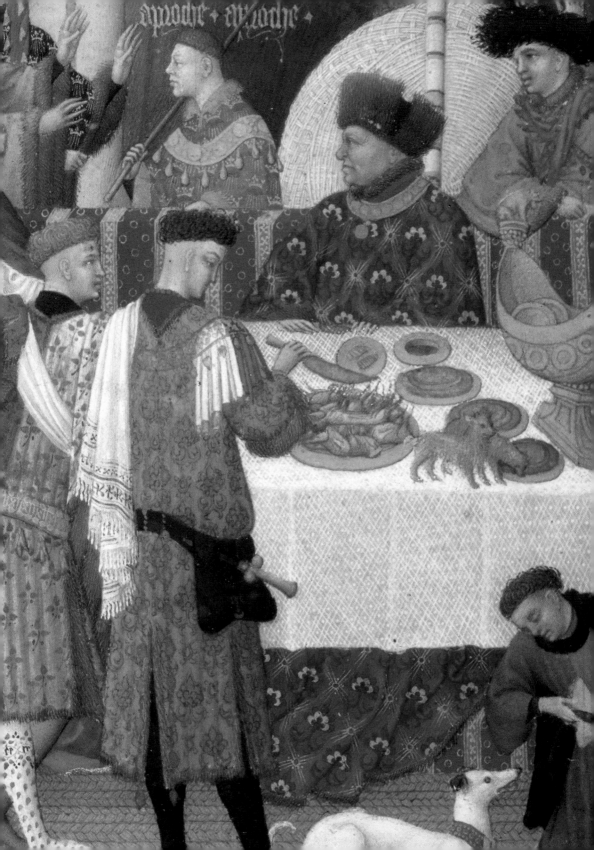

8 The Limbourg brothers
New Year Feast, **illuminated page from *Les Très Riches Heures* of Jean duc de Berri, *c*1415**

Vellum, 29 × 26 cm
Chantilly, Musée Condé

In the Middle Ages the banquets of the powerful included an ever greater profusion of plates on the table. In front of the Duke one can see a carver at work. His job was to extract the bones, remove the fat, and in general prepare a portion for his lord and any distinguished guests. On the left hand side one can see the sideboard. Here the master of the house kept and ostentatiously displayed his most valuable silverware.

Detail of 8

one depicted in the *Last Supper* in Duccio di Boninsegna's famous *Maestà* (**7**) is, in all probability and despite its bareness, a relatively faithful depiction of a table of this period. On it we see three soup bowls, which were meant to contain a typical soup made with vegetables to which the wealthier added a piece of salted pork. For the poor people of late medieval Europe, such soups were the first, last, and only course of their meals. While the repasts of the middle and upper classes also included these soups, they were followed by a second course. In the middle of Duccio's table, in a strategic position, one can see the roast around which the fancier medieval and Renaissance meals were constructed. In this case the meat course seems to be a roasted lamb which, notwithstanding its obvious symbolic meaning, was (and still is) a typical dish served in Italy at Easter.

Although there are no less than twelve people partaking of this meal, there are only three bowls, four knives, and four glasses on the table. We might think that such details have been glossed over by the painter, but that would be quite incorrect since, in fact, the medieval diner had fewer objects on the table than we do today. Bowls for soups and trenchers for the roast and other solid foods did not have the same function as our present-day plates, which are meant for only one person at a time. Instead, these items were strategically placed between two or three people who ate from them together. Soups were usually eaten out of shared bowls, also using shared spoons. Otherwise, the only cutlery used at the table were knives (often shared by the diners) to cut the food which was then further broken up and eaten with fingers.

This sharing of cutlery, glasses, bowls, and trenchers brought with it a specific code of manners in which more attention was paid to

the person with whom one shared the food than to the other diners. For example, the *De Quinquaginta curialitatibus ad mensam* (Fifty rules for the table), composed by Bonvesin de la Riva toward the end of the thirteenth century, reminded its readers to wipe their mouths before drinking from the shared cup of wine, not to put bread into the wine for fear of disgusting one's neighbor, and so on. Eating in the Middle Ages was a far less private affair than it is today.

With the coming of the Renaissance, a new table etiquette began to take shape in southern Europe, whence it slowly spread to the rest of the continent. The sharing, which was so typical of medieval repasts, was replaced by an increasingly individualized way of eating in which everyone had his own plate, glass, knife, and spoon. This slow but steadily increasing need for people to have their own private dimension while eating caused invisible walls to go up around each diner, an isolation further established with the introduction of forks. Although forks had already been known in the high Middle Ages, having been imported from Byzantium, they remained a little used curiosity. By the end of the fourteenth century, this "new" contraption had been adopted in Florence but did not gain favor elsewhere in Europe until later.

In his *Crudities*, published in 1611, Thomas Coryat expresses a certain reluctance with respect to forks, which had not as yet been widely adopted north of the Alps: "I observed a custom in all those Italian cities and towns through the which I passed, that is not used in any other country that I saw in my travels . . . the Italians and also most strangers who are commorant [resident] in Italy, do always at their meals use a little fork" The somewhat indirect explanation he gives for the adoption of the "little fork"—at that time a smaller version of the prongs used by the

9, 10 Master of the Orange Cloister
St Benedict receives the poisoned bread
Fresco, 218 × 306 cm
Florence, Badia Fiesolana
Each monastic order had its own, slightly different rules concerning food. Simplicity was achieved by respecting an essentially vegetarian diet. Meat and fowl were meant to be served only on particular feast days. In these scenes St. Benedict receives a loaf of poisoned bread given to him by monks of his Order dissatisfied with what they considered to be excessively rigorous standards, but is warned by an angel.

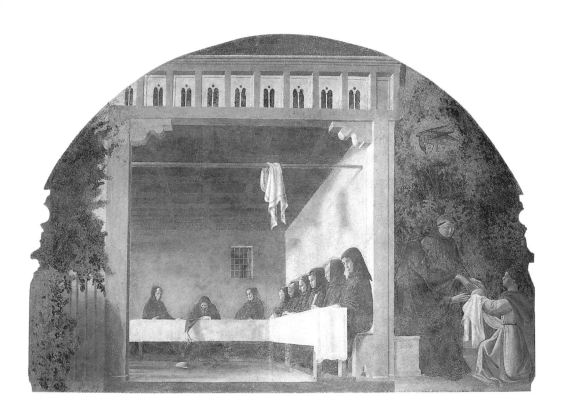

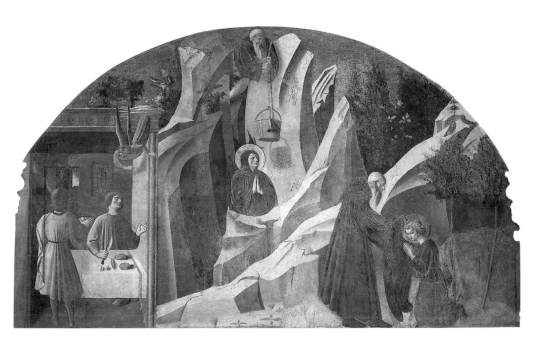

19

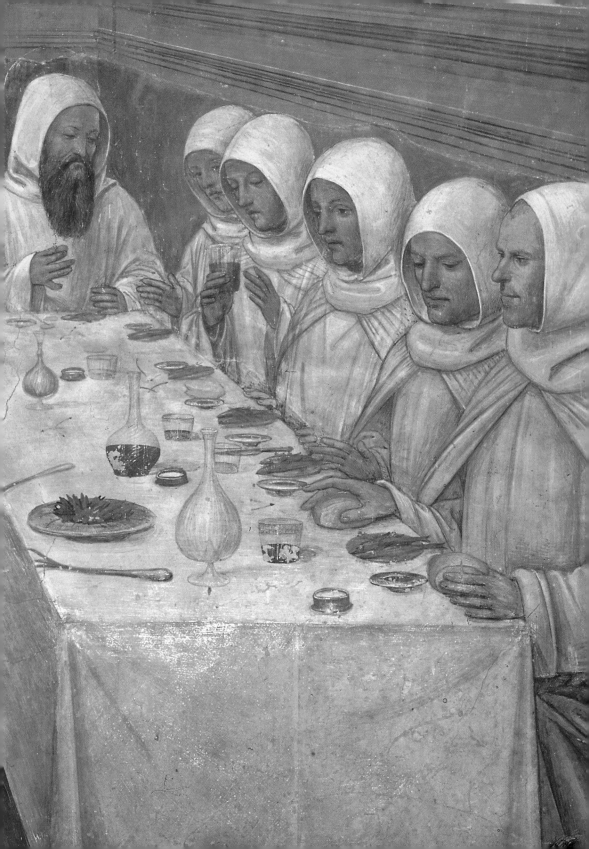

meat carvers present at all medieval and Renaissance tables—introduces his readers to a "new" custom, a new need for diners to have less contact with their other table mates: "The reason for this their curiosity is, because the Italian cannot by any means endure to have his dish touched with fingers, seeing all men's fingers are not alike clean." Some thirty years earlier Montaigne's comment concerning the lack of napkins at German tables is equally revealing with respect to French eating habits: "I could eat without a tablecloth, but to dine in the German fashion, without a clean napkin, I should find very uncomfortable. I soil them more than the Germans or Italians, as I make very little use of either spoon or fork."

11 Giovanni Antonio Bazzi, il Sodoma
St Benedict feeding the monks, 1505–07
Fresco
Siena, Abbey of Monte Oliveto Maggiore
Most religious orders called for two meals a day, a lunch and a dinner, which were served somewhat earlier than is usual today. The working classes, on the other hand, ate more often. In most of Europe they ate two major meals as well as two (in summer three) short breaks to eat and drink.

Detail of 11

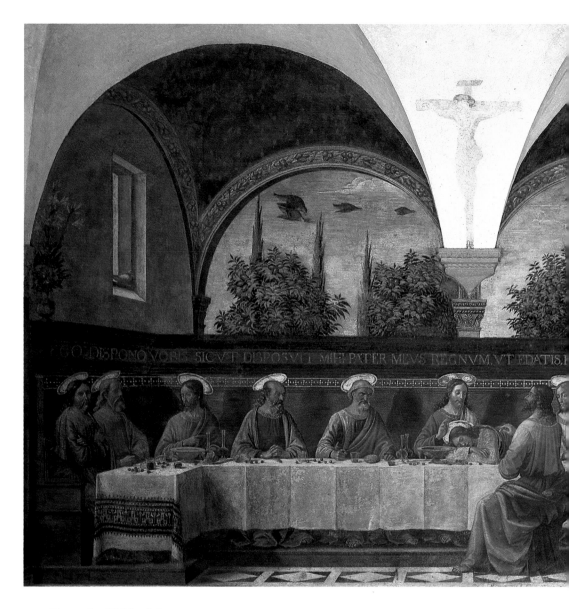

12 Domenico Ghirlandaio
The Last Supper, late 15th century
Fresco
Florence, Cenacolo of Ognissanti

Many Renaissance banquets were held in a covered portico looking onto a garden. Fruit (there are cherries and apricots on the table) was a luxury item reserved for the tables of the wealthy. Yet, in so far as fruit was a relatively recent addition to European diets, it was heartily condemned by most doctors, who considered it to be unhealthy.

The mature Renaissance

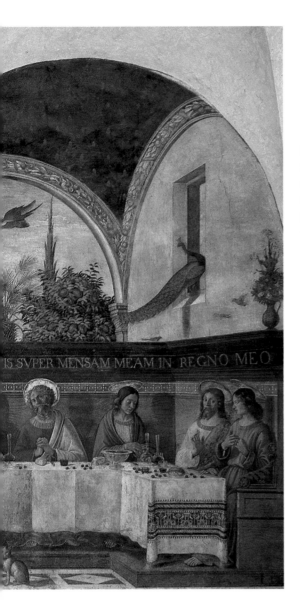

The Renaissance, with its new interest in man's terrestrial life, brought about a new attitude to the portrayal of food in art. Painters no longer fled the idea of painting food and foodstuffs, but showed a newly developed curiosity for these aspects of life. A surprising realism is exhibited by an unknown fifteenth-century master who painted a vegetable market in a lunette of the Castle of Issogne in the Aosta Valley in Italy (**13**). The detail of this fresco does not shy away from such simple things as melons, chestnuts, tresses of garlic and onions. Furthermore, it seems to intimate that most of the fruit and vegetable vendors in such markets were women, a fact that is confirmed by both archival and literary evidence.

The end of the Middle Ages saw the introduction of new plants such as lemons, oranges, artichokes, asparagus and aubergines, although such exotics were only gradually adopted. Most of these novelties had originated in the Orient and were introduced to Europe by the Arabs, whose western expansion was responsible for the migration of many new plants and foodstuffs. Plants from the New World tended to be treated with similar caution. Potatoes, tomatoes, peppers, and most of the beans we know today—all imported from the newly discovered continent during the sixteenth century—were for the most part not readily adopted by the inhabitants of the Old World. An exception was the pepper plant, whose different varieties had an almost immediate success in Europe, and by the end of the sixteenth century peppers were widely grown. The almost instant success of this plant, so untypical of the slow and extremely cautious

13 Anonymous artist
A market in a portico of Issogne Castle,
15th century
Fresco
Aosta Valley, Issogne Castle

This market scene features tresses of garlic and
onions alongside various kinds of leafy
vegetables, all of which were used in pie
recipes found in the cookbooks of this period.

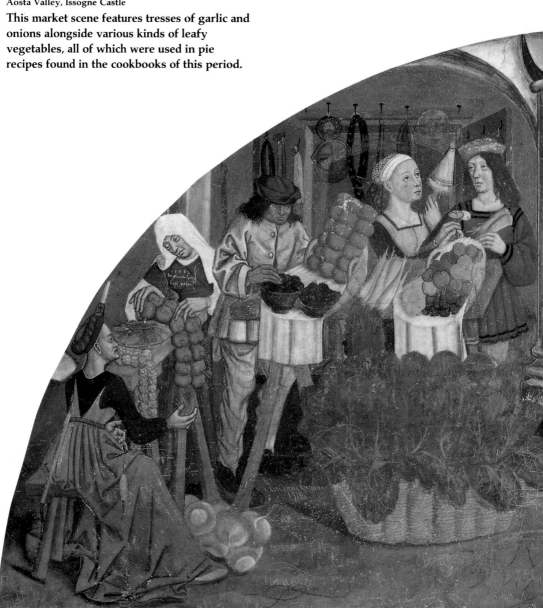

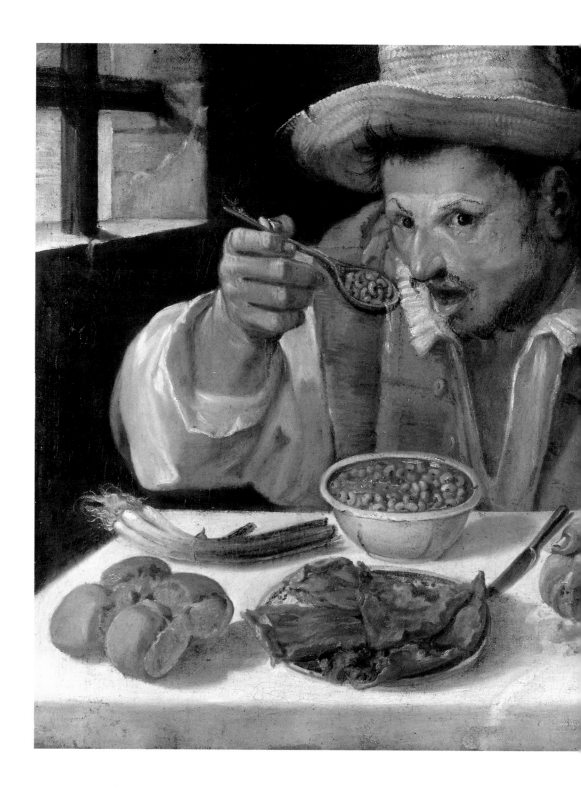

adoption of new foodstuffs, might have been due to its sharp and distinctive taste reminiscent of the peppercorn, for which it was a cheaper substitute. Peppercorns imported from the East could hardly be afforded by the rural populations of early modern Europe.

Even the beans of the *faseolus* family did not fare well in the beginning, though they eventually replaced the African beans which were eaten earlier and had long been known in Europe, having been described by the Greek botanist Theophrastus. The *faseolus* beans were not grown in Europe until well into the seventeenth century, despite the fact that they produced a far more abundant harvest than the African. The well-known painting by Annibale Carracci, the *Bean-eater* (1585) (**14**), shows a farmer with a bowl of beans which are big enough to be identified as the ancient *vigna unguiculata* bean of African origin, today known as black-eyed susans from the typical dark spot where the bean is attached to the pod.

The precision of Annibale Carracci's painting is not limited to depicting this bean variety; it is also one of the earliest known portraits of a man eating what was once a fairly typical meal for the poor (and the not so poor) in late sixteenth-century Italy. On the table in front of the diner there are, besides the bowl of beans, all the most basic elements:

14 Annibale Carracci
The bean–eater, **1585**
Oil on canvas, 57 × 68 cm
Rome, Galleria Colonna

This unusual painting illustrates a typical poor man's meal. Notice the onion, an important element in a simple meal during the sixteenth century, in which it served as a substitute for meat. During the seventeenth century, there was a marked rise in the price of meat which therefore appeared still more rarely on the tables of the laboring classes.

bread, onions (which are still eaten with bread in rural Italy), salad, a pitcher, and a glass of wine. The lack of meat is conspicuous but must have been usual. Sir Robert Dallington, an English traveller to Tuscany a few years after Carracci painted his *Bean-eater*, remarked that "Concerning herbage, I shall not need to speake, but that it is the most generall food of the Tuscan, at whose table Sallet [salad] is as ordinary, as Salt at ours; for being eaten of all sorts of persons & at all times of the yeare: of the riche because they have to spare; of the poor, because they cannot choose; of many Religious, because of their vow, of most others because of their want"

Although such a parsimonious attitude to food might have been widespread, it is also true that the Renaissance was fond of elaborate banquets. In early sixteenth-century Florence, for example, there had been a "Compagnia del Paiuolo" (Company of the Cooking Pot) founded by a group of twelve famous—and less famous—artists. This group (which included Andrea del Sarto) met upon occasion for elaborate dinners. The rules of the company decreed that each one of the banqueters had to bring a dish for supper that was to be "prepared with some beautiful invention." The dish was to be presented to the master of the feast, who then would give it to one of the other banqueters. Thus each man exchanged his dish for that of another and, "when they were at table, they all offered each other something from their dishes," so that "every man partook of everything."

The "inventions" served in these banquets could be quite elaborate, even constituting extravagant pieces of culinary architecture. In one case, Andrea del Sarto came to the gathering with "an octagonal temple similar to the Baptistry of Florence but raised upon columns. The pavement was a large plate of aspic with a mosaic pattern made with several

15 Pieter Aertsen
A fish market, c1560
Oil on panel, 127 × 85 cm
Cologne, Wallraf-Richartz Museum
In most of Europe fish was a luxury that cost far more than even the best meat. The only exception was salted herring, which fed people all over Europe during the forty days of Lent and the more than a hundred other days of the year on which Christians were supposed to abstain from meat. Salted tuna was available in southern Europe and to some extent substituted for herring, which had to be imported from the north.

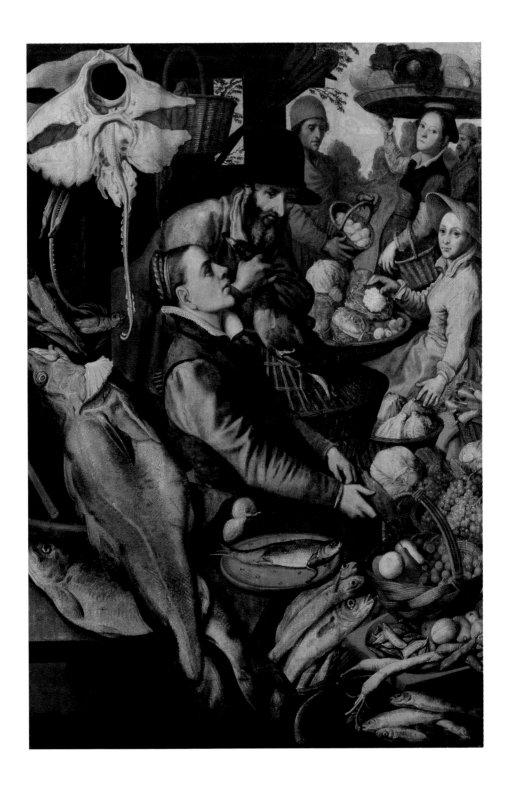

colors. The porphyry columns were made with long and thick sausages while the socles and capitals were made with Parmesan cheese. The cornices of the temple were made of sugar and the tribune was made with pieces of marchpane. In the center of the dish was a choir-desk made of cold veal on which rested a book of lasagne that had the letters and musical notes made with peppercorns. The singers at the desk were cooked thrushes standing up with wide opened beaks and wearing little shirts made of fine cauls of pigs. Behind them, two fat young pigeons sang the bass parts while six ortolans sang the soprano ones."

Culinary constructions such as Andrea del Sarto's edible temple sounded a kind of echo of the legendary land of Cockaigne, a land were sausages grew on trees, fountains ran with wine, and where roasted chickens walked about, complete with a knife sticking out of their succulent breasts, to offer themselves to the grossly overfed inhabitants. This dream-land, which compensated for all the frustrations and unfulfilled desires experienced in this world, shows the importance ascribed to food in a culture which was always perilously close to famine. Pieter Bruegel's *Land of Cockaigne* (**16**), which shows farmers lying around with unbuttoned pants after eating all there was on a maypole, visualizes a dream of repletion which the lower classes fulfilled only on rare occasions. *The peasants' wedding* (**17**), for example, shows one of these festive occasions and it is painted with the food and drink shown in the foreground, since they were more important than the bride herself.

The ruling classes had a different attitude to food, in so far as they scarcely had to fear the consequences of famine. Although their everyday meals might have been very "tempered" (*i.e.* frugal) as one English traveler to Italy pointed out, their banquets can only be

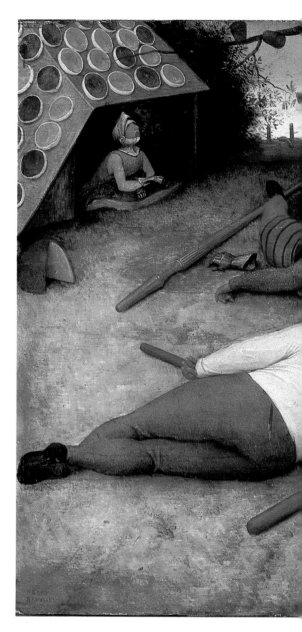

16 Pieter Bruegel the Elder

The Land of Cockaigne, 1567

Oil on panel, 52 × 78 cm
Munich, Alte Pinakotek

The chronic lack of food with which a majority of the population was forced to live gave rise to a myth of a land in which all was abundance and in which food literally begged to be eaten.

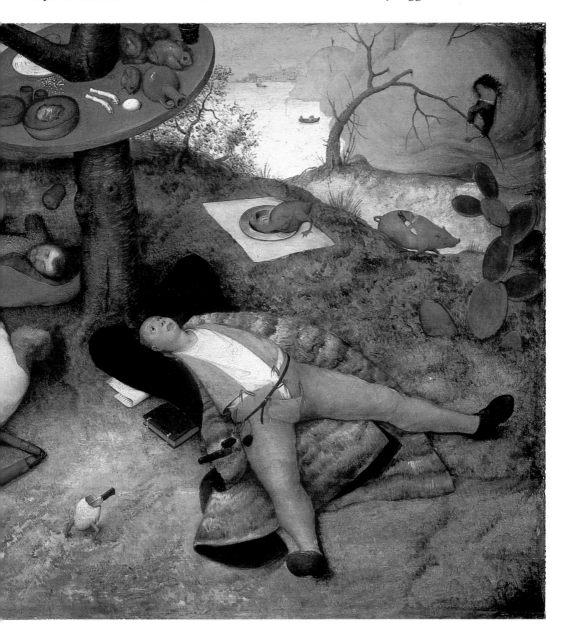

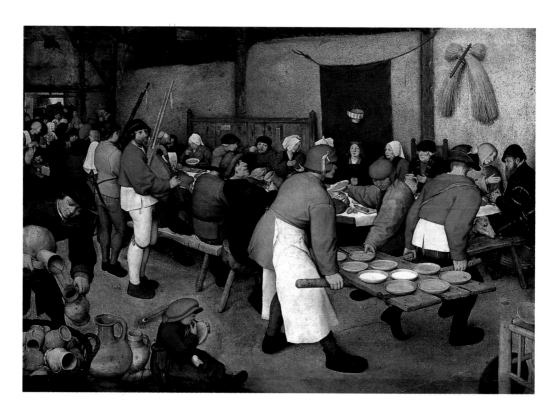

17 Pieter Bruegel the Elder
The peasants' wedding, *c*1568
Oil on panel, 114 × 163 cm
Vienna, Kunsthistorisches Museum

Feast days, such as marriages, were the occasion for excessive
drinking and eating, especially in conditions when supplies were
generally short. Here the bride almost disappears behind the
tumult of food, drink, musicians and guests. In this famous
picture the food, rather than the bride, is the protagonist.

Detail of 17

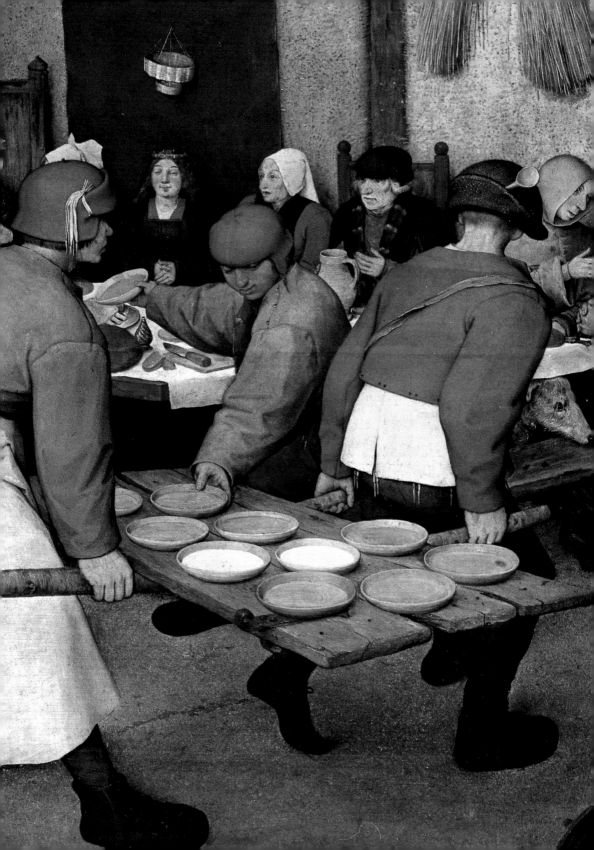

compared to a potlatch in which the wealth and the power of the diners was expressed by the amount and the variety of foods served. A cookbook published in 1557 by the Master of Ceremonies at the Court of Ferrara provides us with precise accounts of some of the meals served at that court. A "private" dinner for only twenty people called for an introductory course which consisted of twenty portions of salad, twenty bowls of milk, six portions of liver sausage, six portions of roasted peacock and rice sprinkled with sugar as well as six portions of olives. After this "appetizer," the diners washed their hands and the real meal began: three courses made up of seven dishes each, a fourth course with three dishes, a fruit course with seven dishes, and, finally, after a second washing of hands, three dishes of confectionery (totalling thirty-four dishes). To a modern eye these dishes and courses do not follow any perceptible "order" since one finds oranges and lemons as the last dish of the first course and "fennel and other fruit in vinegar" as one of the fruit dishes.

Much attention was paid to the purely decorative aspects of a banquet, although banquets, like all other meals, were consumed more or less wherever the diners chose, since tables and rooms specifically devoted to meals had not yet been developed. Paintings show us that trestle tables could be set up in bedrooms as easily as on a terrace which afforded a view on to a garden. And the more elaborate a meal, the more frequent were the table decorations. Whereas paintings depicting religious subjects usually omit or are very sparing in their representations of table decorations, this is not the case with depictions of the banquets of the powerful. These tended to be highly ornamental affairs. Every detail, from the hundreds of ways in which to fold napkins to the festoons decorating the room, was studied and prepared for the occasion. The food itself took on a decorative function, with pies representing gardens and sweets bearing the coat of arms of the host. The colors of different dishes were considered important. French, English, Italian, and German cookbooks of the Renaissance period often dwell on the color of a dish and on the different ways in which special effects could be achieved. A variety of coloring agents were used, including herbs for a brilliant green, saffron for yellow, toasted bread for brown or black, red cedar for red and pink, mulberries—or even ground lapis lazuli—to bring about a much appreciated "sky blue", not to mention the gold and silver leaf which was used to cover roasts (and which was eaten).

During the sixteenth century it became fashionable to decorate the tables of state banquets with sculptures made with a relatively expensive foodstuff: sugar. In 1529 a banquet held by Ippolito d'Este for several hundred people featured a series of sculptures, each about twelve inches high, representing Venus, Bacchus, and Cupid. According to a contemporary account these statuettes were "partially gilded and painted with beautiful colors". Such statuary was not always produced by anonymous artisans: the series of sugar sculptures made for the wedding banquet held in honor of Maria de' Medici's marriage to Henri IV of France in 1600 were made by Pietro Tacca, the most important sculptor in Giambologna's workshop. They represented various mythological scenes and included as well an equestrian statue of the bridegroom. At about the same time Tacca also made bronze versions of the same statues which, unlike the all too ephemeral sugar versions, survive today (**18**).

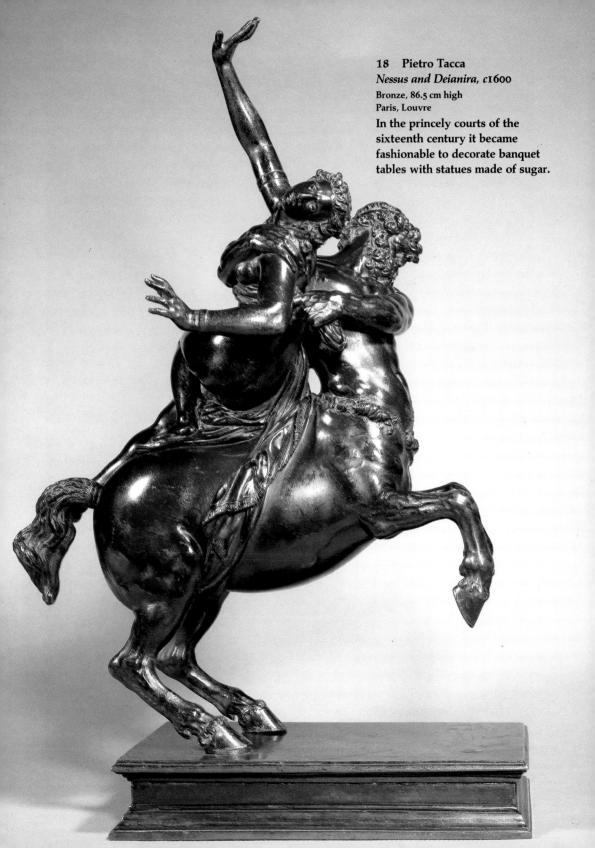

18 Pietro Tacca
*Nessus and Deianira, c*1600
Bronze, 86.5 cm high
Paris, Louvre
In the princely courts of the
sixteenth century it became
fashionable to decorate banquet
tables with statues made of sugar.

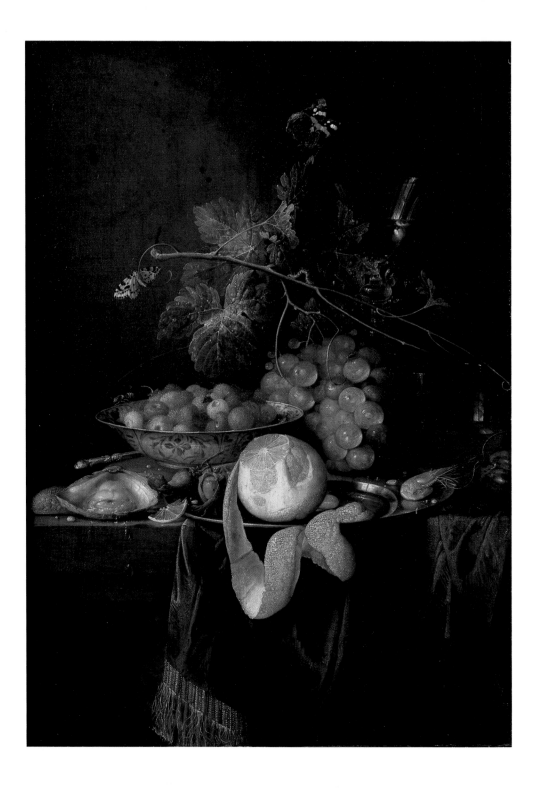

The seventeenth and eighteenth centuries

Painters of the seventeenth and eighteenth centuries did not depict tables and food in a radically different way from their predecessors, but they did develop, sometimes extensively, ideas that earlier artists had only toyed with, above all in the "still life". Whereas late Renaissance painters such as Beuckelaer and Aertsen in the Netherlands gave more attention to foodstuffs than ever before, they still portrayed it in a logical setting, such as a market stall or a kitchen. But in the seventeenth and eighteenth centuries the food increasingly was separated from its context and took on a life of its own. Not only in Northern, especially Dutch art, but also in Italy, France, and Spain, the still life of food became a subject worthy of attention, an important genre which has survived to this day. Such paintings would have been unthinkable and reprehensible in medieval and even in early Renaissance art, and their appearance constitutes a vivid and tangible proof of an unselfconscious hedonism. When its tables are compared to the bare tables of the Middle Ages and the early Renaissance, this new age seems to revel in earthly delights. However, these laden paintings very often betray a deep-seated uneasiness since they were partly justified as a portrayal of the biblical "vanity of vanities."

Moreover, artists of the seventeenth century picked up and extrapolated another late sixteenth-century theme which is of interest: portraits of poor people preparing, cooking, or eating food. To the example of the *Bean-eater* by Annibale Carracci (**14**), one might add the rather more disquieting *Old woman cooking eggs* by Diego Velázquez (**21**). The food portrayed in these two masterpieces emphasizes

19 Jan Davidz de Heem
Still life, c1650
Oil on canvas, 59 × 43 cm
Paris, Louvre

In the seventeenth century the upper classes adopted a great number of new foodstuffs which had previously been consumed only by the lower classes. This new interest for "inferior" foodstuffs (which, however, did not include the newly arrived plants from the New World) revolutionized the way in which the elite ate. Curiously, the change in diet seems to have had an artistic parallel in the still-life genre, in which food became a popular pictorial subject at this time.

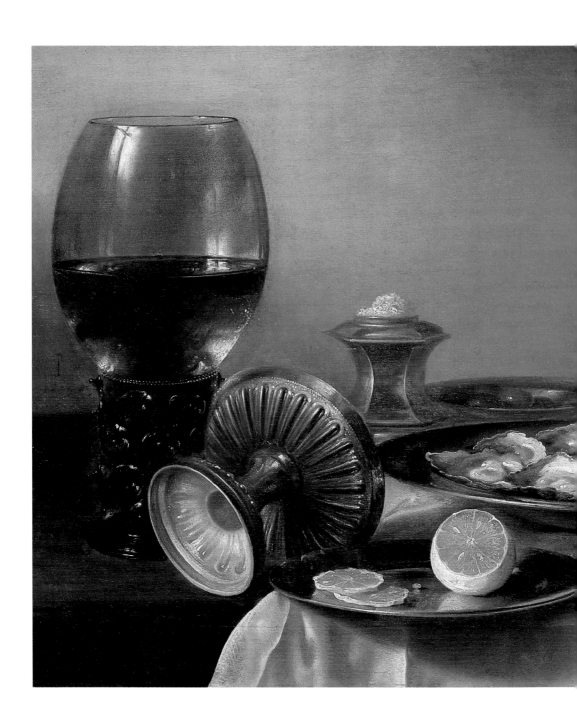

20 Pieter Claesz
Still life with oysters and a goblet, 1642
Oil on canvas
Boston, Museum of Fine Art

Oysters were long considered a lowly food. During the seventeenth century, a turning point in European eating habits, oysters and many other foods lost this association and began to appear on the best of tables.

the low social status of their subjects—an effect enhanced by the somewhat distorted featuresof the bean-eater. And it should put us on our guard against reading paintings such as Caravaggio's *Supper at Emmaus* (**22**) as another example of a humble meal, an impression partially conveyed by its setting in an unassuming room. In fact, this *Supper*, like most Renaissance paintings depicting meals involving Christ, tells a very different story: both its fruit and its fowl (a chicken or guinea-hen?) were, *par excellence*, food consumed by and attributed to the rich and powerful. Like many other painters before and after him, Caravaggio did not paint Christ consuming low-status food but rather placed on the Lord's table a lordly meal.

Although certain attitudes toward food as a means of social differentiation persisted from the Renaissance into the seventeenth century, food and especially cookery changed more rapidly and more radically than ever before in history. Its evolution had, according to some historians, much in common with twentieth-century developments and so can properly be called the first *nouvelle cuisine*. Such a surprising comparison with a recent fashion in cookery is not an idle one. In both cases a new generation of cooks and cookbook writers refused the cookery of the previous age because they felt that it did not respect the

21 Diego Velázquez
Old woman cooking eggs, 1620–22
Oil on canvas 99 × 117 cm
Edinburgh, National Gallery
The simple meal portrayed in this painting is also an allegory of age and time, contrasting the birth (the egg) and decay (the old woman). Notice, again, the presence of an onion which in this case is painted realistically enough for its variety to be determined: the common Mediterranean red onion which is still cultivated today.

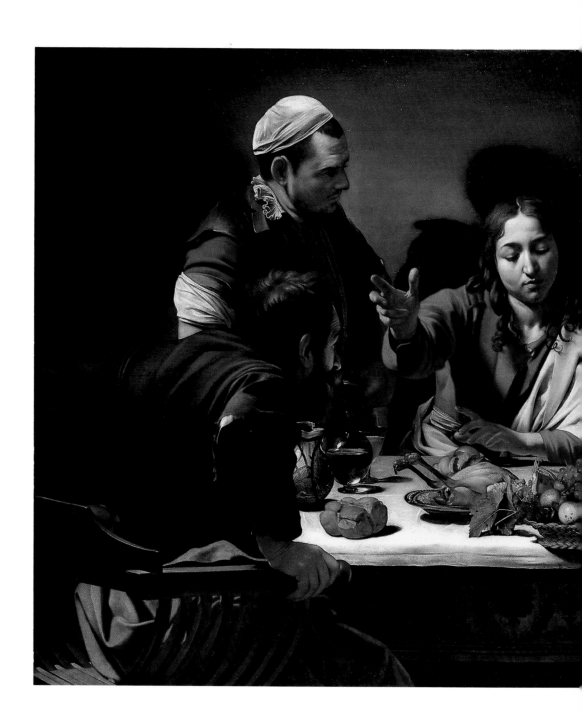

22 Michelangelo da Caravaggio
The Supper at Emmaus, 1599
Oil on canvas, 139 × 195 cm
London, National Gallery

Although the meal in front of Christ might
seem to be simple and unassuming, the
presence of a chicken and of fruit indicates the
presence of an "important" person, one of
social or spiritual superiority.

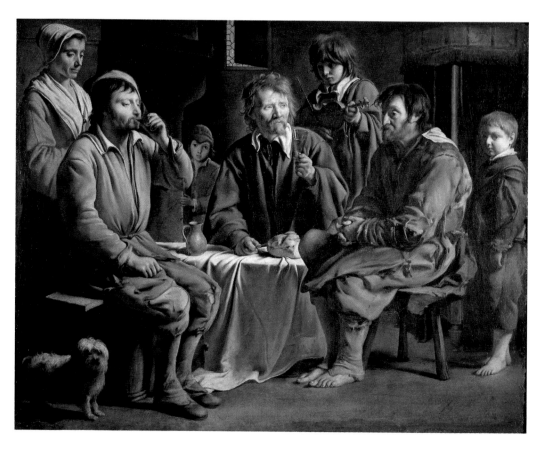

inherent nature of the raw materials used. Whereas the *nouvelle cuisine* of the twentieth century condemned the heavy sauces which were the hallmark of nineteenth-century cooking, the seventeenth century refused the excessive use of spices which had been so common in medieval and Renaissance food. For these new cooks, the medieval idea of using strong spices which predominated over the dish—whether meat, fish or fowl did not seem to matter—was a condemnable heresy as well as a measure of rampant bad taste. *L'Art de Bien Traiter*, an influential cookbook published in 1674 and signed by a mysterious L.S.R., roundly stated this point when the author pointed out: "Nowadays a prodigious overflowing of dishes, an abundance of rag-

23 Louis Le Nain
The peasants' meal, 1642
Oil on canvas, 97 × 122 cm
Paris, Louvre
Even the simplest and most informal meal required a tablecloth. On a table, on a board, or even on the ground, tablecloths separated and set off the area where one ate.

24 Lubin Baugin
A meal of wafers, c1630
Oil on canvas, 41 × 52 cm
Paris, Louvre

Desserts or sweets as we know them today were unknown in the past. Sweet dishes could appear more or less at any point in a meal since there was no clear separation made between sweet and salty dishes. Sugar was considered to be a spice like any other and was used accordingly. However, in the seventeeth century, many a meal ended with *gaufrettes* or wafers as shown here, which are still familiar today even though they are usually associated with ice-cream.

oûts and gallimaufries, and extraordinary piles of meat do not constitute a good table . . . [nor do] confused mixtures of diverse spices, mountains of roasts, or successive services in which it seems that nature and artifice have been entirely exhausted . . . It is rather the exquisite choice of meats, the delicacy with which they are seasoned as well as the neatness and courtesy with which they are served . . . [that matters]."

Another similarity between the cuisine of the seventeenth and the twentieth centuries is the use of many new ingredients. Whereas present-day *nouvelle cuisine* is characterized by relatively exotic ingredients which have not been much used in European cookery, seventeenth-century cooks often adopted

25 Jan "Velvet" Brueghel
The banquet
Oil on canvas 149 × 203 cm
Madrid, Prado

A somewhat more genteel version of his father's (17) *Peasants' wedding*, "Velvet" Bruegel's" banquet scene shows how "guests" who were not seated at the table could nonetheless participate in banquets. Left-overs were usually distributed according to a precise system which took into account the social status of the person receiving them. Cooked foods went to the more highly ranked people while bread and wine were given to the rest.

foodstuffs that had been previously considered undignified for the upper classes. There was a substantial increase in the use of vegetables—some new ones included—constituting a radical departure from the previous age in which roast meat had been the basis of a dignified meal. The horticultural revolution which accompanied this deep-seated change in European culinary habits was already well underway in southern Europe in the sixteenth century, witness the vegetable gardens on the premises of every respectable Italian villa. However, it was not until the seventeenth century that the new fashion gained momentum and spread to France, England, and the Netherlands. A statistical analysis of some 11,500 cookbook recipes from the fourteenth to the eighteenth century shows clearly the steadily growing importance of vegetables in upper-class diets. Whereas only 9 per cent of the recipes of the fourteenth and fifteenth centuries were devoted to vegetables, sixteenth-century cookbooks show a slight increase (to 10.4 per cent), and the seventeenth century leaped to an unprecedented 22.6 per cent. An equally telling story is recounted by the increased number of plants consumed in the same period. The cookbooks of the fourteenth and fifteenth centuries mention twenty-four kinds of plants used in cooking, the sixteenth century twenty-nine, while the seventeenth century shows an increase to fifty-one different plants.

A third similarity linking the two periods of *nouvelle cuisine* is the way in which both broke ground by combining ingredients previously considered to be incompatible. The seventeenth century broke with what had been a fundamental dichotomy between fish and meat. Previously the alternation between religiously determined "lean" and "fat" days had dictated the use of fish or meat, olive oil or

animal fat, etc. The cooks of this century broke with this taboo and combined the two in the same dish, an intuition which was soon forgotten again, until the cooks of modern *nouvelle cuisine* tried it again in the 1980s.

One must not, however, stress the similarities too much because the differences are also very great. For somebody living today a meal in the seventeenth and eighteenth centuries would have seemed completely chaotic. The structure of the meals served at this time was very different from the one we respect today. Whereas the sixteenth century had already begun to serve very elaborate meals with a great deal of dishes, this tendency was continued and even accentuated in the following two centuries. A dinner served in May 1788 to Louis XIV represented one of the high points in the history of complicated meals. The first course of the meal brought with it no less than twenty-six different dishes, the second course another twenty-six (including eight types of roast) while the dessert included some thirty dishes. The banquet was made up of eighty-two different dishes. Such meals do not seem to have been exceptional at this time in European history and did not involve the nobility only. Some seventeenth-century cookbooks written for the middle classes recommended that a dinner for six or seven people carry at least seven different dishes per course, while a dinner for twenty-seven called for twenty to twenty-five dishes per course.

This incredible profusion of dishes can be seen in the paintings of the period, where the plates literally cover every inch of the table. One must not, however, make the mistake of thinking that people ate an inordinate amount of food in this period of European history. The explanation is much simpler. Nobody ate from all of the dishes served in all of the courses. That would have been impossible, not

26 Gonzales Coques
An artists' dinner,
Oil on canvas, 59 × 75 cm
Paris, Musée du Petit Palais

During the sixteenth and seventeenth centuries pewter plates
were used in northern Europe while in southern Europe glazed
earthenware was more common. Montaigne's *Journal* of his trip
to Italy in 1580–81 is a mine of information on food and table
manners at that time. In one of his entries he remarked that, in
the town of Levanella (Tuscany), there was a very fashionable
and particularly good tavern where the food was served on
pewter plates. He reminds his readers that such plates were
"exceedingly rare" in Italy and he is glad to be able to eat off
them. One year later, however, he seems to have changed his
mind and to have preferred the Italian plates to the "pewter
plates of France".

least because each course was left on the table for only fifteen to twenty minutes. Instead, each one of the diners would choose a few dishes in each course, probably no more than two or three, so as to eat a more or less personalized meal. In part this practice reflected what doctors and dieticians had been saying and writing ever since the high Middle Ages. According to them it was important that individuals eat in such a way as to respect and even correct their own nature and constitution, in order to stay healthy. A "melancholic" temperament, for example, was believed to be cold and dry, and thus required a diet of "hot" and "wet" foods (such as strong red wine and lamb) to maintain a healthy balance. A "choleric" temperament, on the other hand, was thought to be hot and dry, which meant that a "cold" and "wet" diet was best (melons, cucumbers, etc.). What is more, because each individual's constitution was further molded and shaped by a series of variables such as the climate in which he or she lived, his or her age and sex, a variety of constitutions could be seated at the same table, all requiring different diets. Each diner was expected to choose among the offerings available and to consume those foods which were most congenial to his or her particular make-up. This principle meant that, as the number of diners increased, so did the number of dishes.

This increasingly complicated way of constructing a meal was called *service à la française,* even though it was not uniquely a French custom. In fact, during the early Italian Renaissance one can see the first indications of its development from the simpler medieval meal. Even early on the phenomenon seems to have been the object of a certain amount of criticism on the part of contemporary authorities, since the sumptuary laws were passed repeatedly in an attempt to curb the ostentation that these meals involved.

27 Cristoforo Munari
Still life with glassware and fruit, c1706–15
Oil on canvas, 55 × 45 cm
Florence, Museo Bardini

Fruit, unlike vegetables, was considered very much an upper-class food. The prices that fruit commanded, especially when it was somewhat out of season, where quite prohibitive. A variety of refined techniques were therefore developed to keep fruit as long as possible.

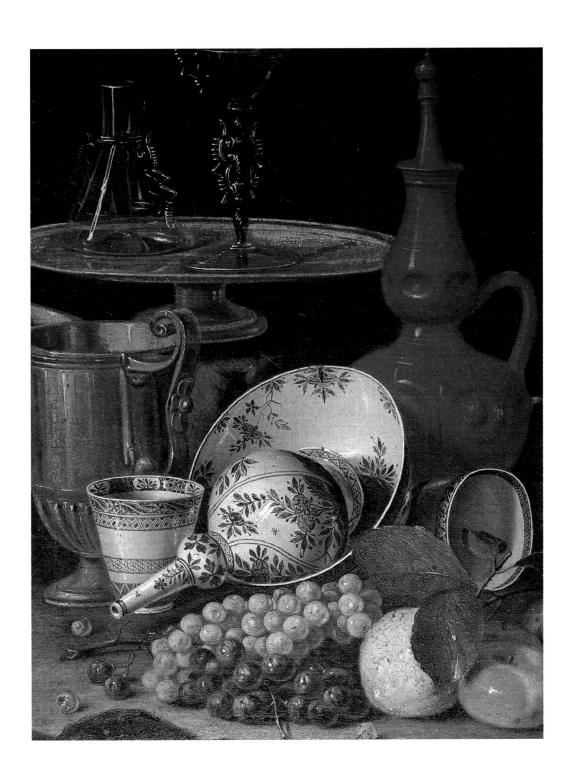

28 John Francis
Still life,
OIl on canvas
Princeton, University Art Museum

Until well into the nineteenth century most doctors considered
milk and milk products to be poor-quality foods that were best
avoided.

29 Baldassarre Franceschini, Il Volterrano
A joke played by the parish priest Arlotto, c1640
Oil on canvas, 150 × 107 cm
Florence, Palazzo Pitti

In Italy, by the seventeenth century, trenchers and shared cutlery
had been replaced by individual plates and tableware, as is
shown in this painting of the mid-seventeenth century depicting
one of the exploits of the notorious practical joker Arlotto.

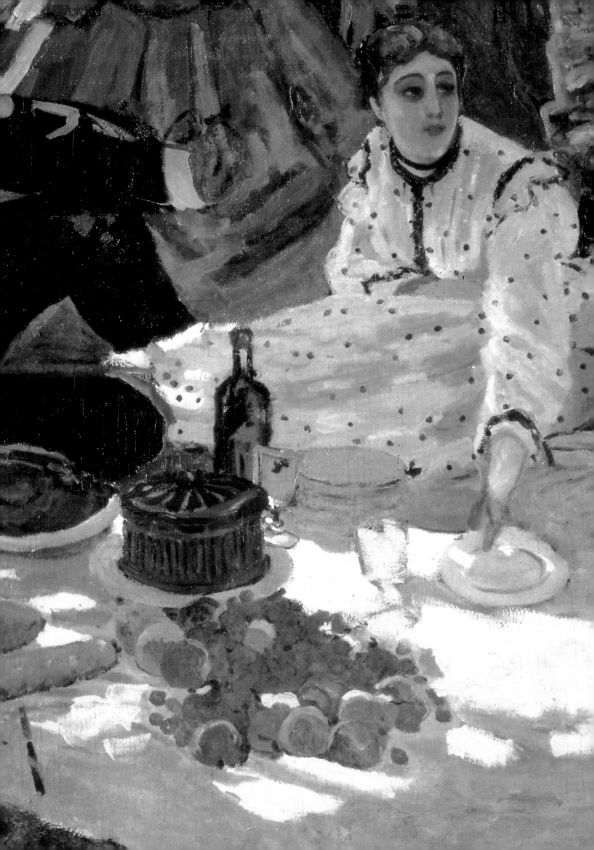

From the nineteenth to the twentieth century

T he last decades of the eighteenth century and the beginning of the nineteenth century saw the end of a system in which most cooks of skill and creativity worked anonymously in the households of the rich and the powerful. From before that time we know practically nothing about cooks and cookbook writers. Although these individuals might have been well paid experts they were still servants. However, when changing social conditions (brought about by the rise of the middle classes) determined an expansion of the scope in which cooks could practice their art, culinary "artists", just like musicians and writers, were no longer confined to a powerful or noble patron and subject to his often capricious good will. Cooks now worked for another and much greater patron: the public. The need to find new and informal meeting places had brought about the birth of restaurants and of a new cuisine. The owner-cooks of these restaurants and, toward the end of the nineteenth century, of great international hotels, were responsible for transforming both meals and cookery into something close to what we know today.

The last century also saw the abandonment of the *service à la française* in favor of the *service à la russe*, in which the food is cut in the kitchen (instead of at the table by the guests), a helping is served to each guest, and everyone eats the same food. Introduced in England and in France around the middle of the century, the *service à la russe* was not universally followed until the 1890s, but was then adopted to the almost total exclusion of the previous system. Today, at least in northern Europe, the only example of the *service à la française* is found in our buffet meals in which everyone

Detail of 30

30 Claude Monet
The picnic, 1865–66
Oil on canvas, 208 × 217 cm
Paris, Musée d'Orsay
The aristocracy had always been happy to eat out of doors. But the middle classes only began to imitate their pastoral pastimes during the nineteenth century when the picnic lunch became a genteel and respectable alternative to the formality of the dining table in the dining room.

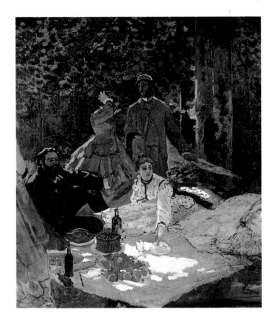

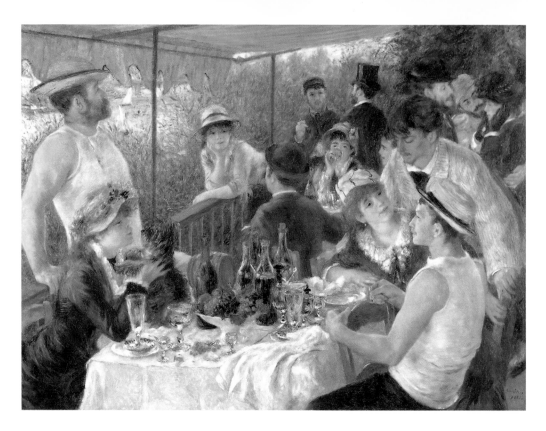

31 Pierre Auguste Renoir
The luncheon of the boating party, 1881
Oil on canvas, 144.7 × 172.7 cm
Washington, Phillips Collection

The late eighteenth century and, above all, the nineteenth
century saw the birth of the modern restaurant. Until the end of
the eighteenth century cooks were the servants of noble families.
However, with the rise of the middle classes, cooks found a new
clientele which made the restaurant an economically viable
institution.

Detail of 31

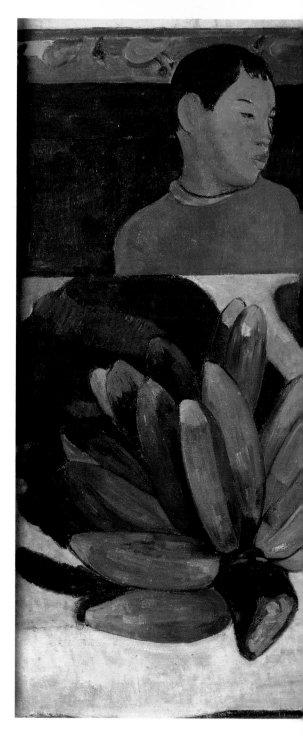

32 Paul Gauguin
A meal of bananas, 1891
Oil on canvas, 73 × 92 cm
Paris, Musée d'Orsay

Bananas had been described by European travelers to Egypt since the Middle Ages. Several of them wrote that this fruit was better than any other, even to the point of affirming that it was the banana, rather than the apple, that had been the cause of the Fall of Man. It was said that the banana contained a portent reminding all who cut it open of mankind's Original Sin: a cross was supposedly visible in all transversally cut bananas!

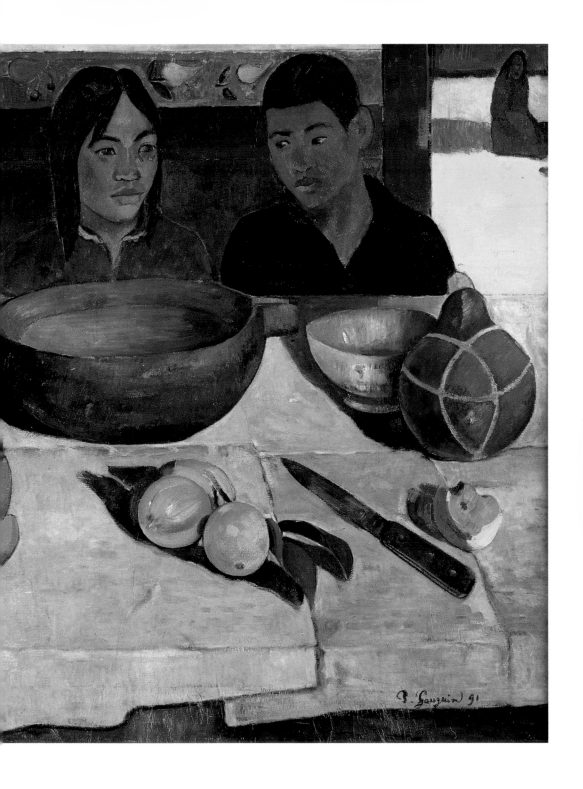

33 Felix Valloton
Dinner in the lamplight, 1899
Oil on canvas, 57 × 89.5 cm
Paris, Musée d'Orsay

Cookery was revolutionized during the nineteenth century by
master cooks such as Antonin Carême, whose influence on
European middle-class cookery is still felt. Studying the world of
the professional chefs and their clientele, however, it is easy to
lose sight of the wider world of domestic cookery—the more
simple fare that average people ate at home every day, not to
speak of the subsistence-level diets of the laboring classes.

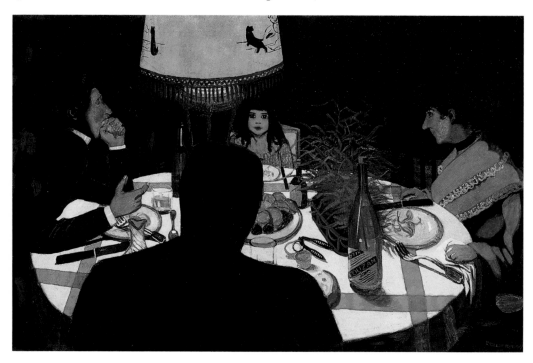

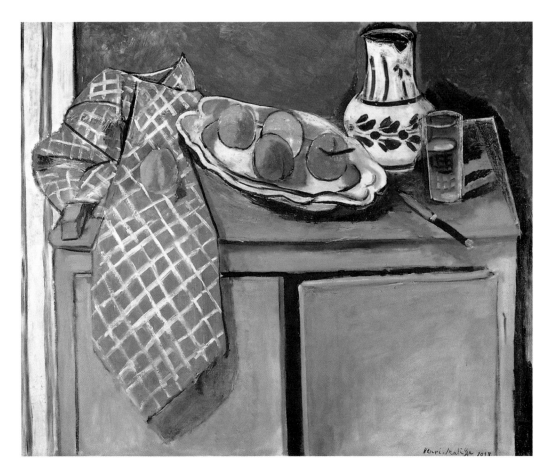

34 Henri Matisse
Still life on a green sideboard, 1928
Paris, Musée d'Art Moderne

The twentieth-century still life has put food into the background where it merges with the other colors and objects of the pictorial space. Here the painter depicts fruit that is no longer a siren-like object of desire, as it was for his seventeenth-century predecessors but rather an object amongst many.

can pick and choose from a large variety of dishes. The *service à la russe*, which it is tempting to regard as a more democratic way of eating, also brought with it a diminished number of dishes and a stricter sequence in which they would appear. The vast majority of present-day meals follow a progression from salty to sweet quite rigidly, in a manner that was not respected in the past.

The depiction of food and eating in art in the last two centuries is almost infinitely varied, and it is difficult to identify essential themes. However, one famous instance in which food itself became part of art must be mentioned: the first Futurist banquet, held at the Taverna Santopalato in Turin in 1931. The

35 Claes Oldenburg

Pastry Case I, 1961–62

Enamel paint on plaster, 52.7 × 76.5 × 37.3 cm
New York, The Museum of Modern Art, Sidney and
Harriet Janis Collection

Whereas the development of restaurants in the
nineteenth century delivered *haute cuisine* to
the middle classes, the invention of "fast food"
in the twentieth century has revolutionized
mass consumption. Here, the typical fare of fast
food outlets is taken out of context and
presented to the viewer's amazement as a
"cultural" product.

36 Andy Warhol

Big torn Campbell's soup can, 1962

Acrylic and serigraphy on linen, 183 × 136 cm
Zürich, Kunsthaus

Various new techniques for preserving food
began to be developed towards the middle of
the nineteenth century, thus revolutionizing the
availability of products not only over the
calendar year but also over large distances.
Canning, which was one of the first of these
techniques to be developed, came under bitter
attack by gastronomes at the turn of the
century; they predicted the certain demise of
grande cuisine with all its hallowed traditions.

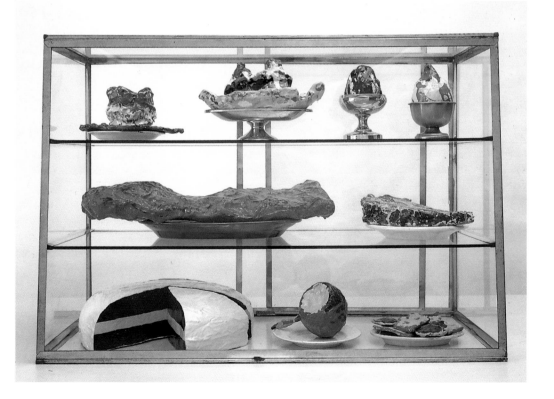

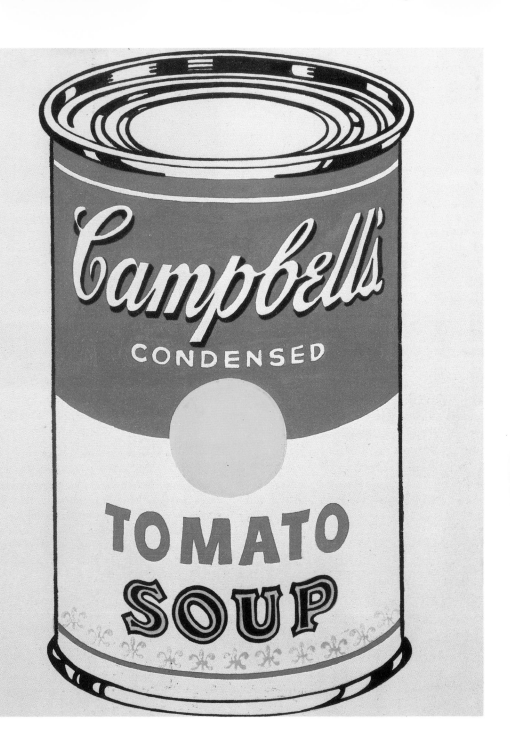

Futurists felt that food and cooking were far too prosaic and even anaesthetized people. Cookery, like the rest of modern living and modern art, needed to be revolutionized. The tavern was decorated in the best Futurist style: an aluminium structure made up of two cubes and columns was painted with fluorescent colors. The menu served consisted of fourteen courses which, it must be said, were in some respects closer to literary inventions than to culinary ones. One of the appetizers served, the "Intuitive Hors d'Œuvre", was made up of an orange-peel basket in which was put a piece of ham wound around a bread stick, a little pickled artichoke, and a pepper which contained a Futurist maxim or a laudatory verse concerning one of the guests. Another course, the "Fragolemammella" (strawberry-breast) dessert, invented by Farfa, was "a pink dish in which there were two erectile female breasts made with *ricotta* [a cream cheese] tinted with Campari and nipples made with candied strawberries...." From such fanciful but often only partially edible dishes to the dried-up pastries which fill Claes Oldenburg's *Pastry Case I* (**35**), there is a long story to be told about how the twentieth century has altered our perception of food and our culinary habits.

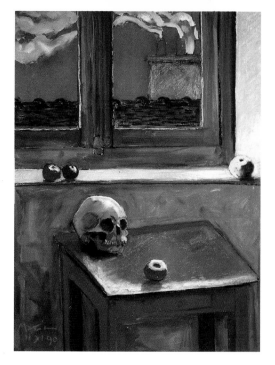

37 Maxime Preaud
Adam's remorse, 1990
Oil on canvas, 46 × 64 cm
Collection of the artist
The apple in this painting harks back to the one Eve held in her hand at the beginning of time. Here the sense of guilt no longer resides in gluttony and in lust, but rather in the melancholic symbol of an endlessly represented and continually reinterpreted Original Sin.